TESSELLATION
coloring book
BY
Pretty Laks Designs

© 2019 Pretty Laks Designs

All Rights Reserved

Book Layout, Illustration © Pretty Laks Designs

No part of this book may be reproduced, scanned or distributed in any printed or electronic form without prior permission from the author.

Tessellations Coloring Book by Pretty Laks Designs
ISBN : 9781091896420

Hello!

30 fun hand illustrated pages are waiting for you. Whether you are a beginner or a pro, there are designs to challenge every skill level. Coloring is not only fun, but also stress relieving and relaxing for the mind.

Crayons, colored pencils, gel pens, fine markers and watercolor pencils are recommended to for use. Don't limit yourself with these choices, just slide a blank piece of paper or two under the coloring page when using thicker medium.

I hope you enjoy coloring as much as I enjoyed creating these designs!

Thank you,
 Laks

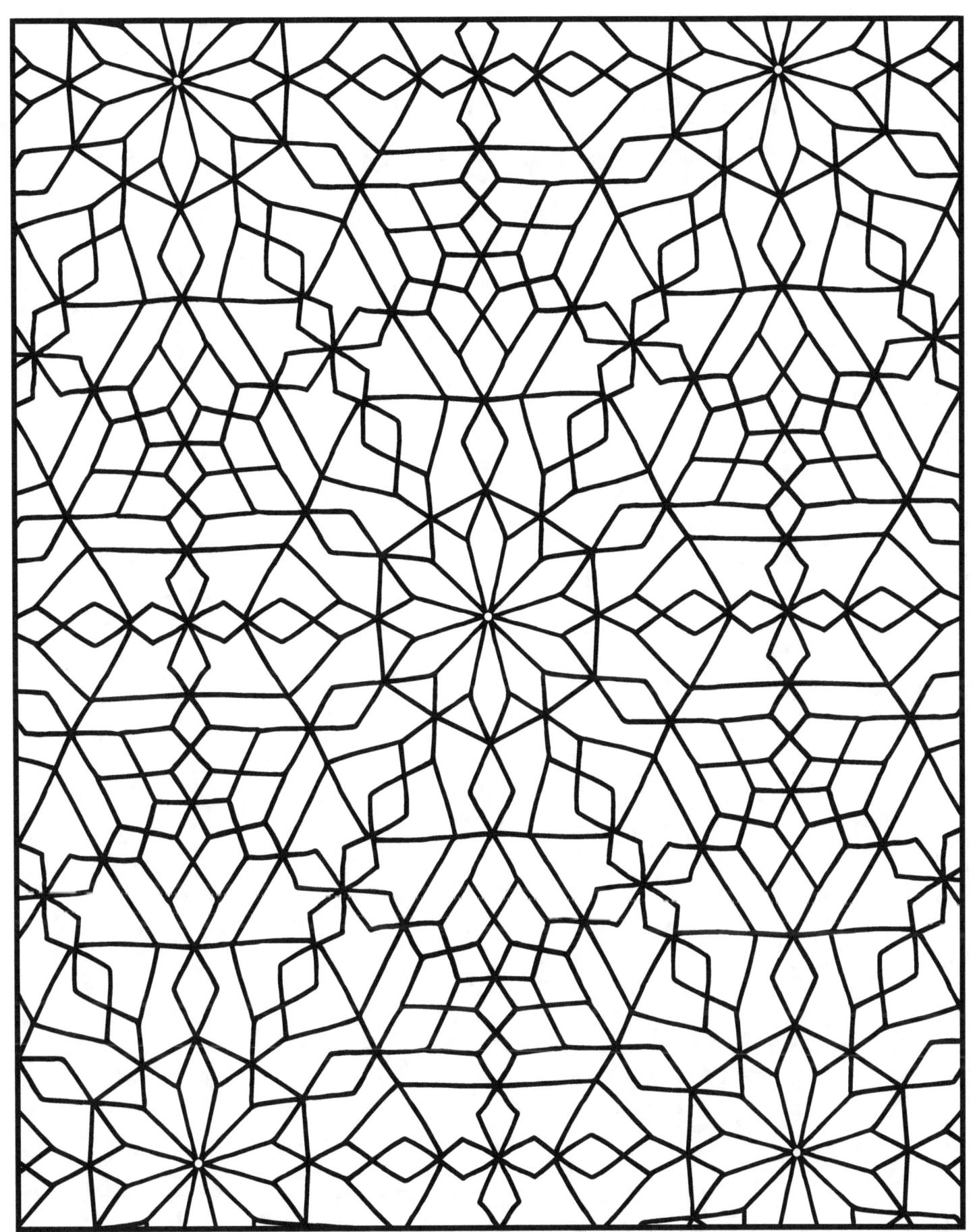

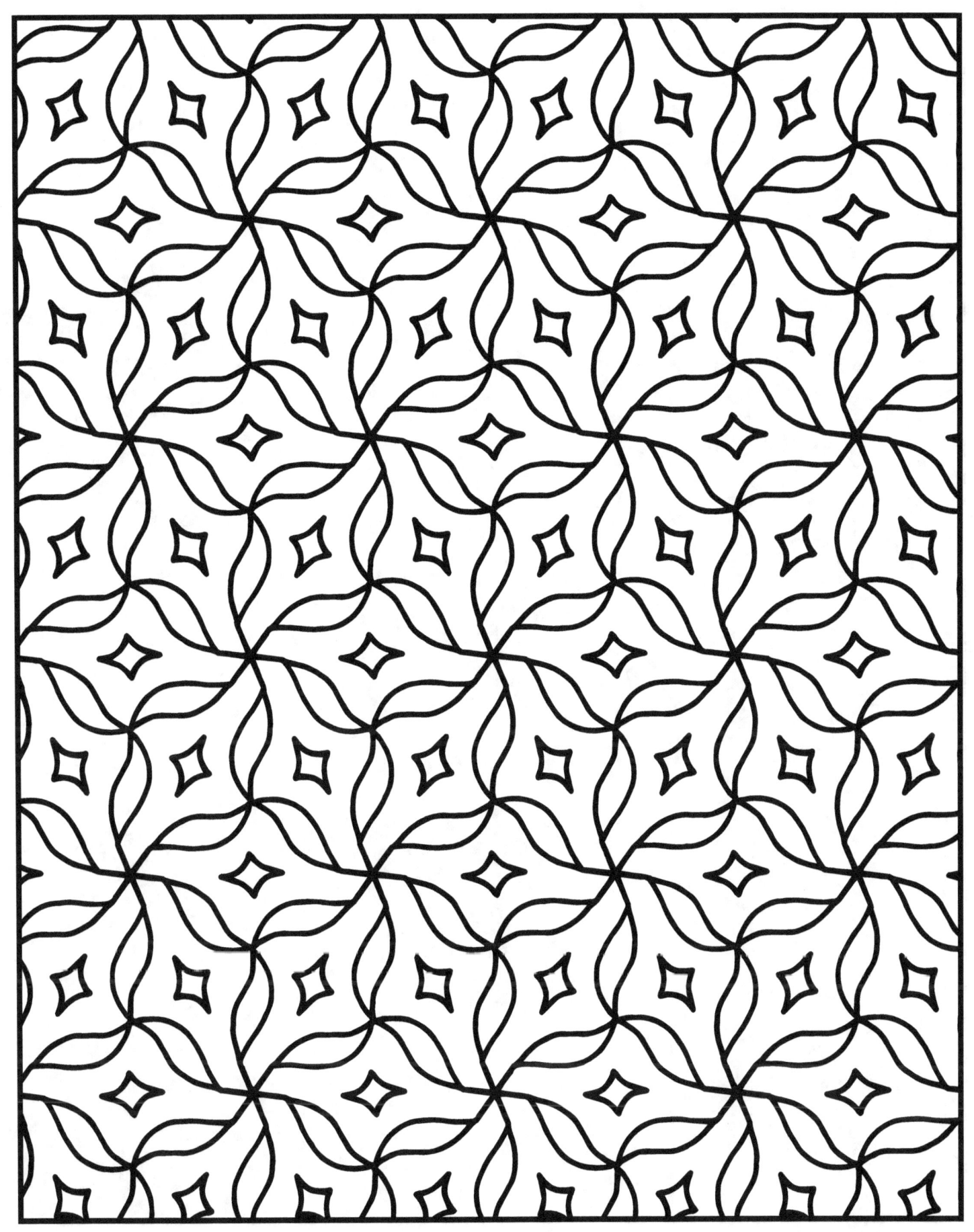

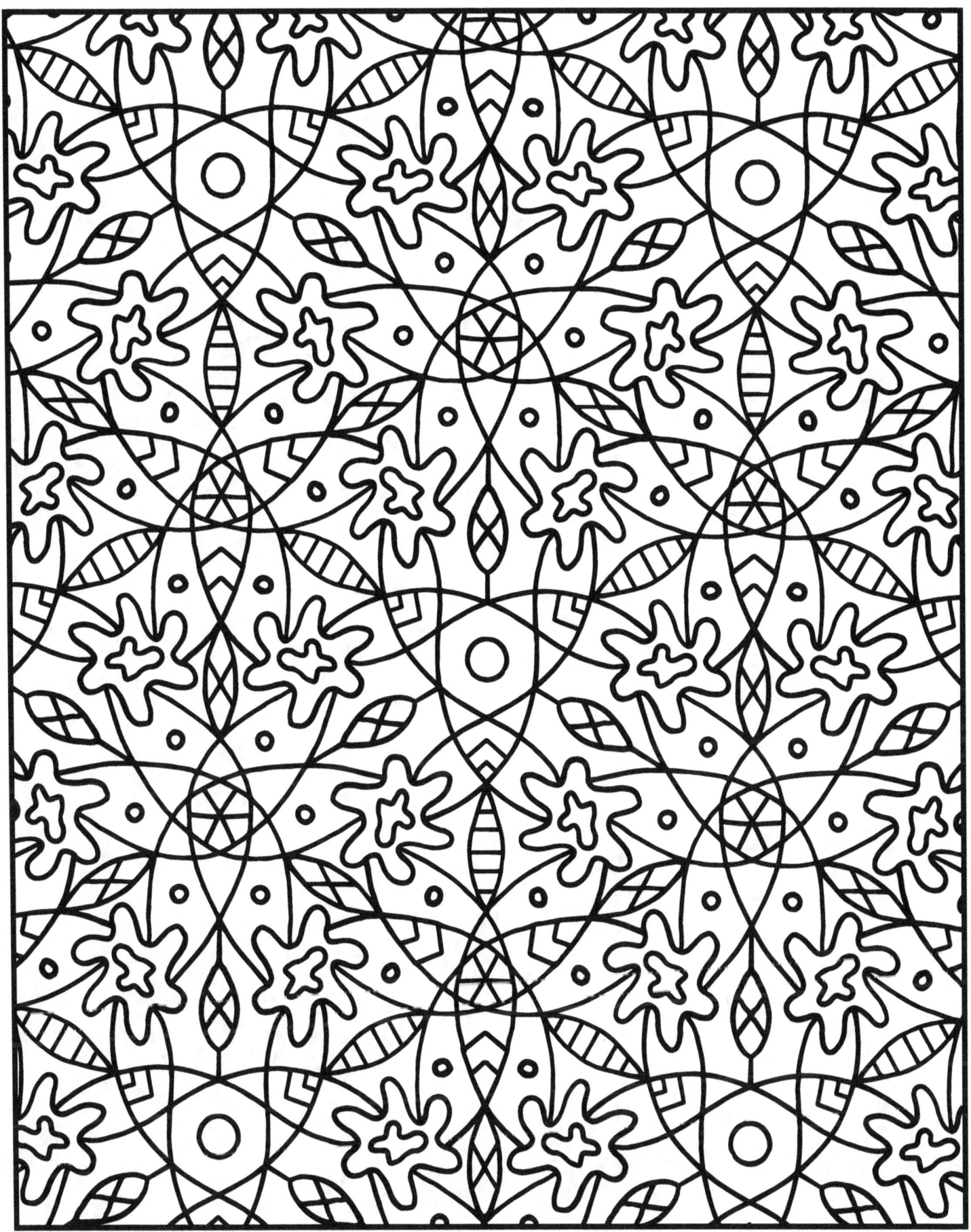

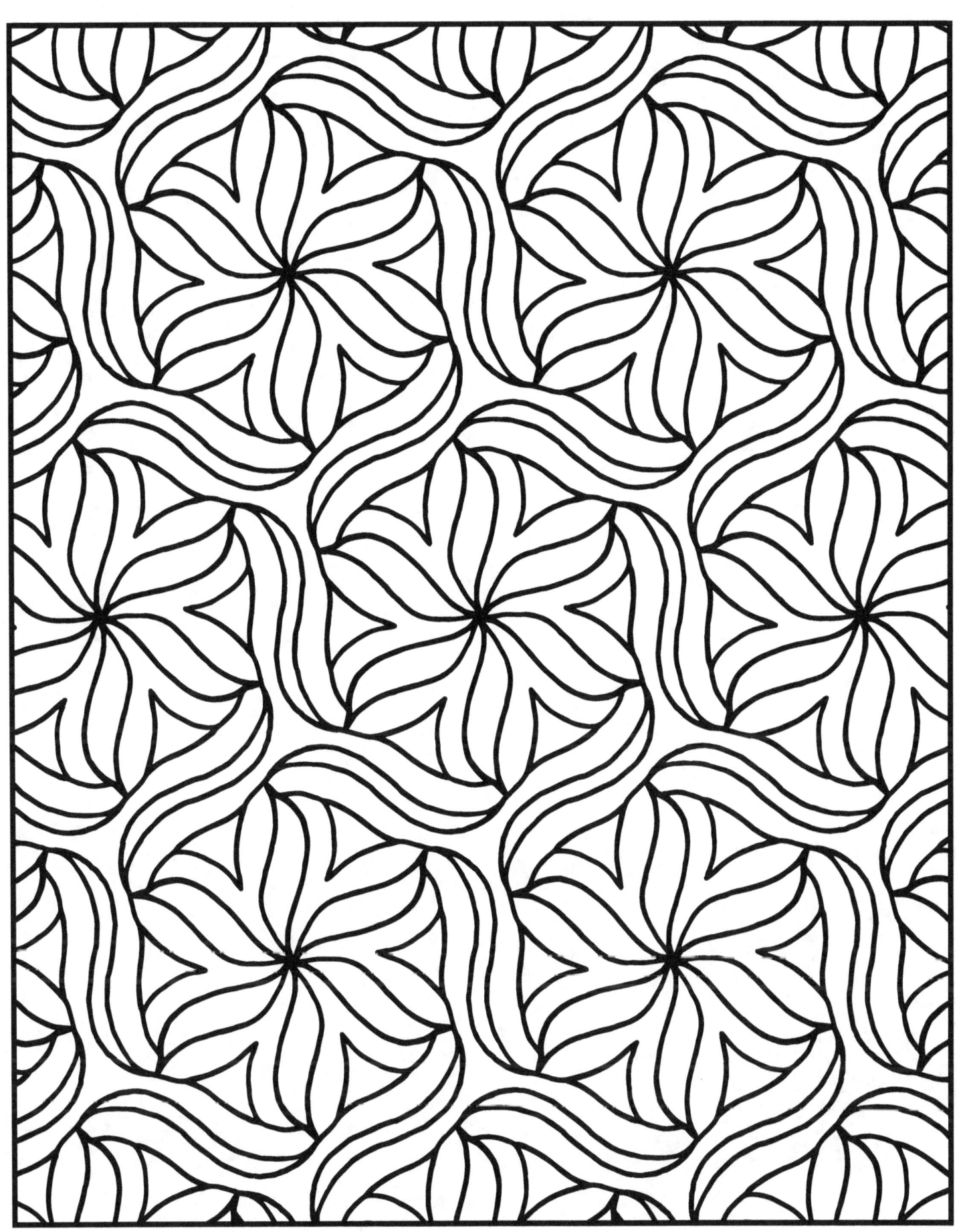

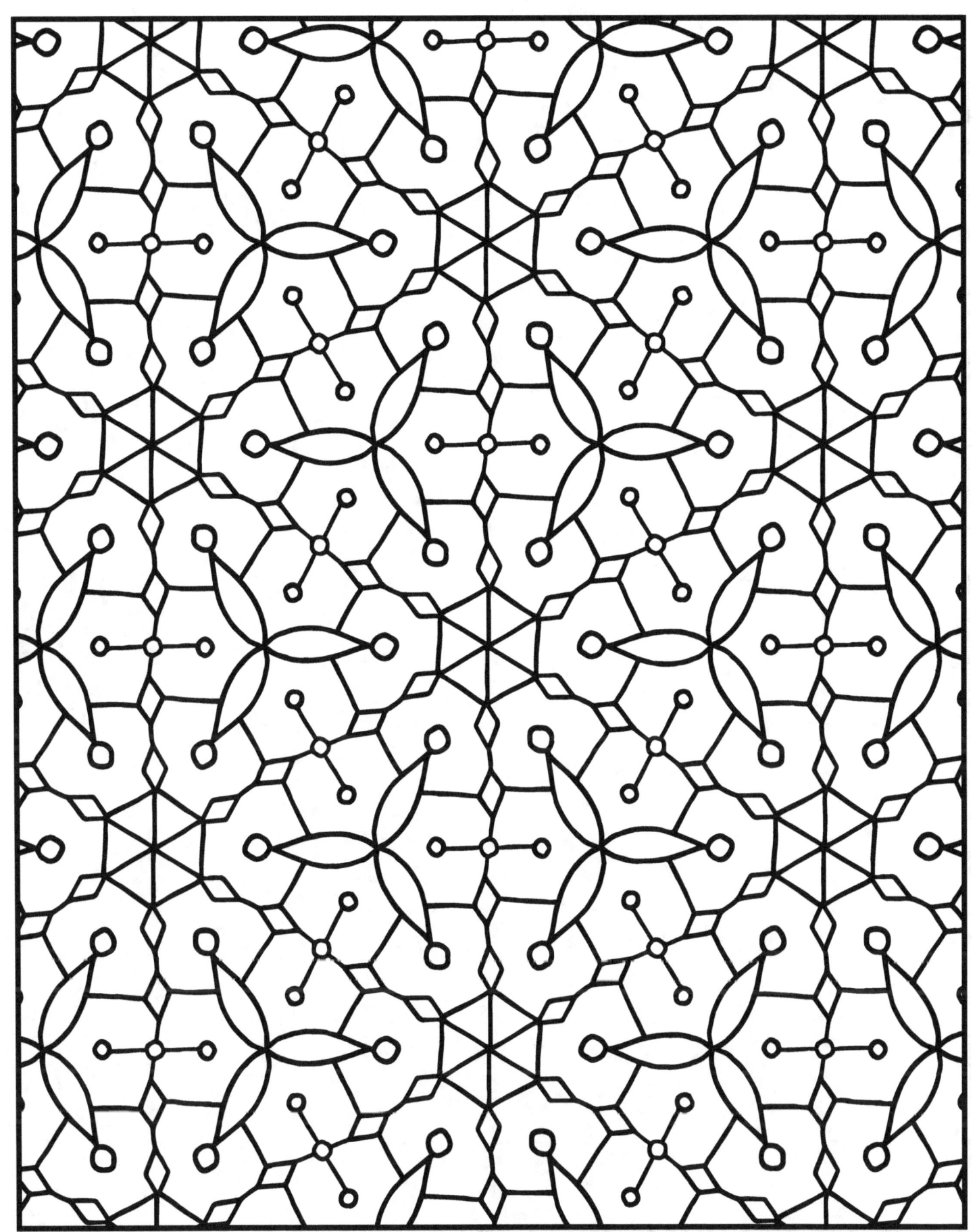

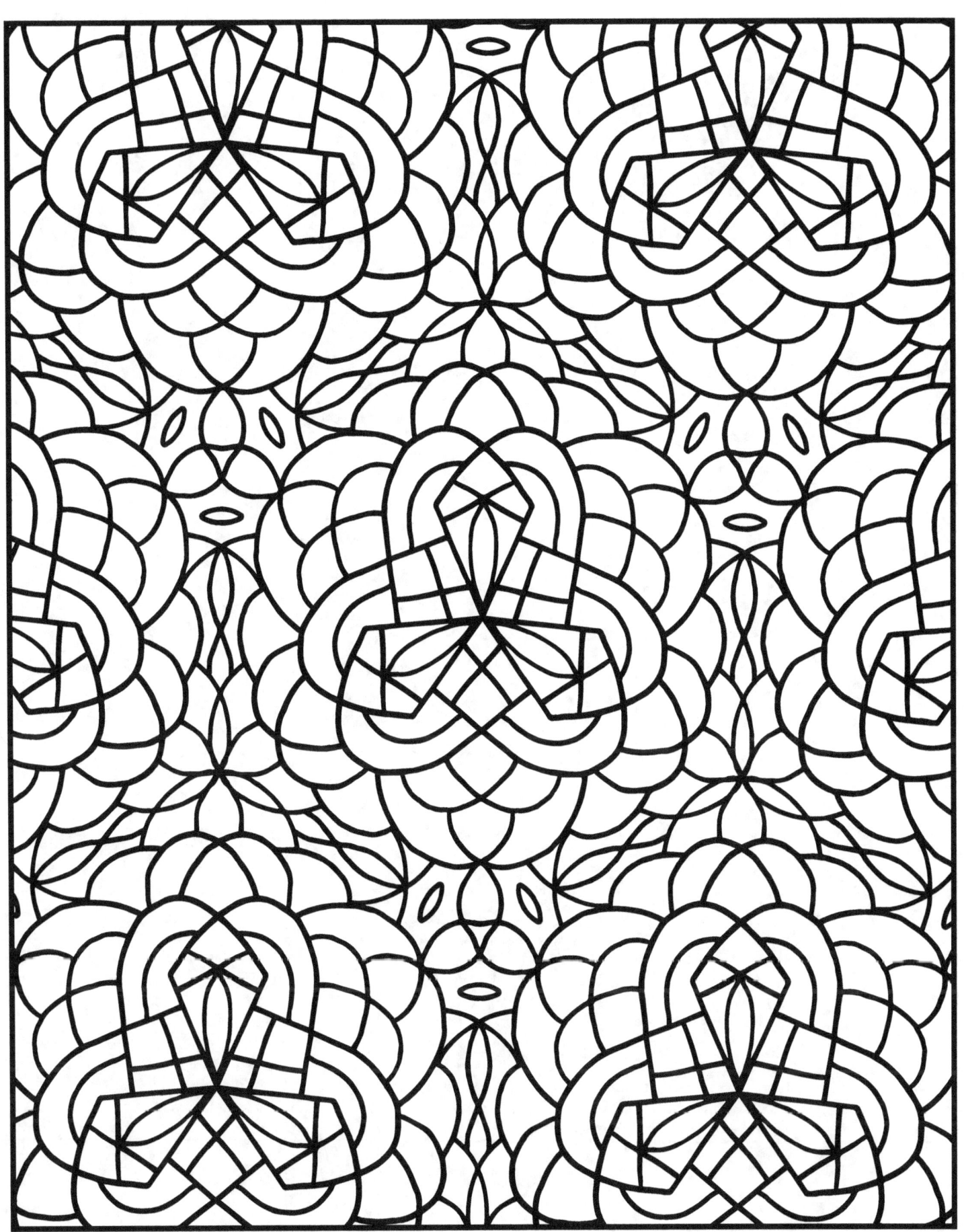

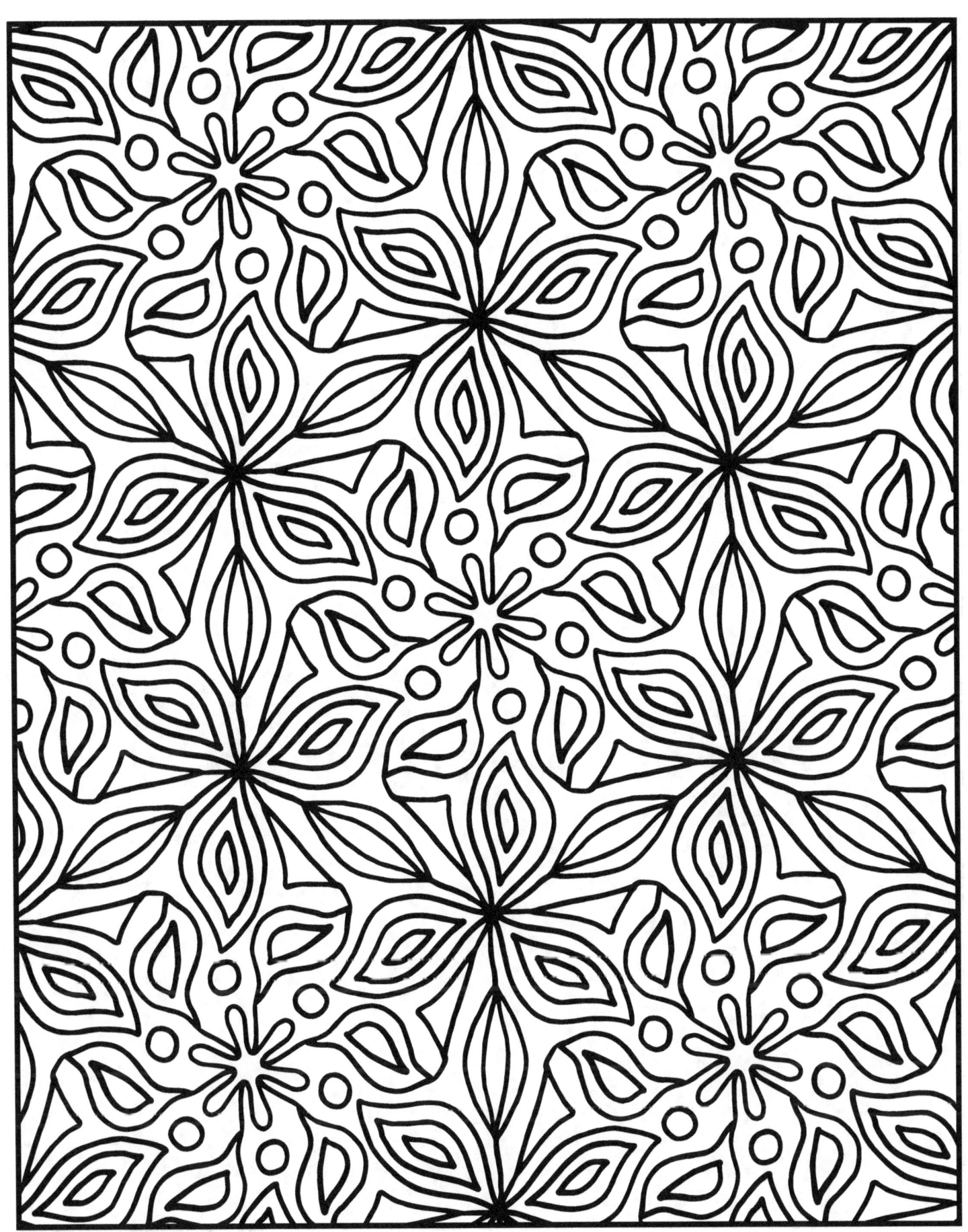

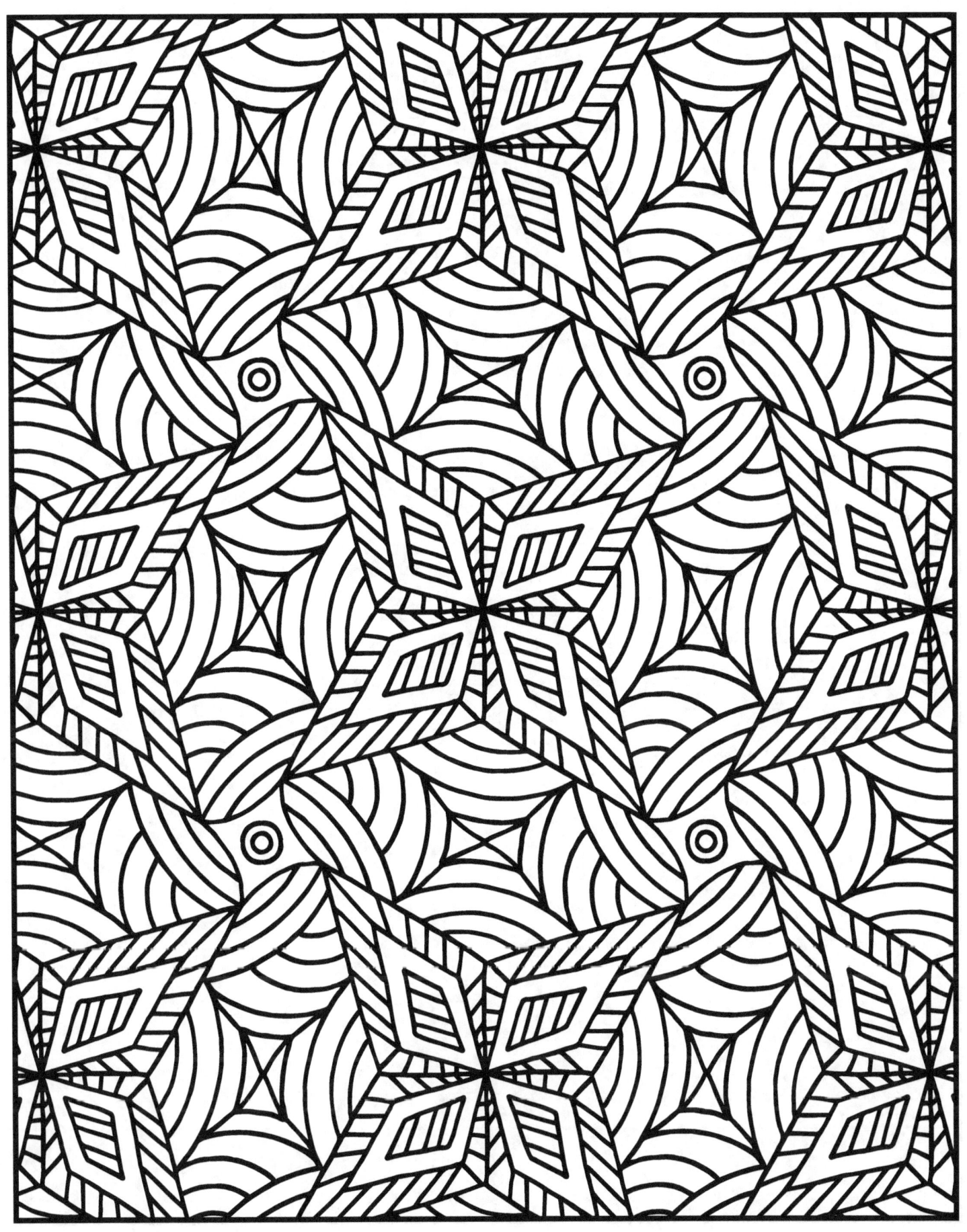

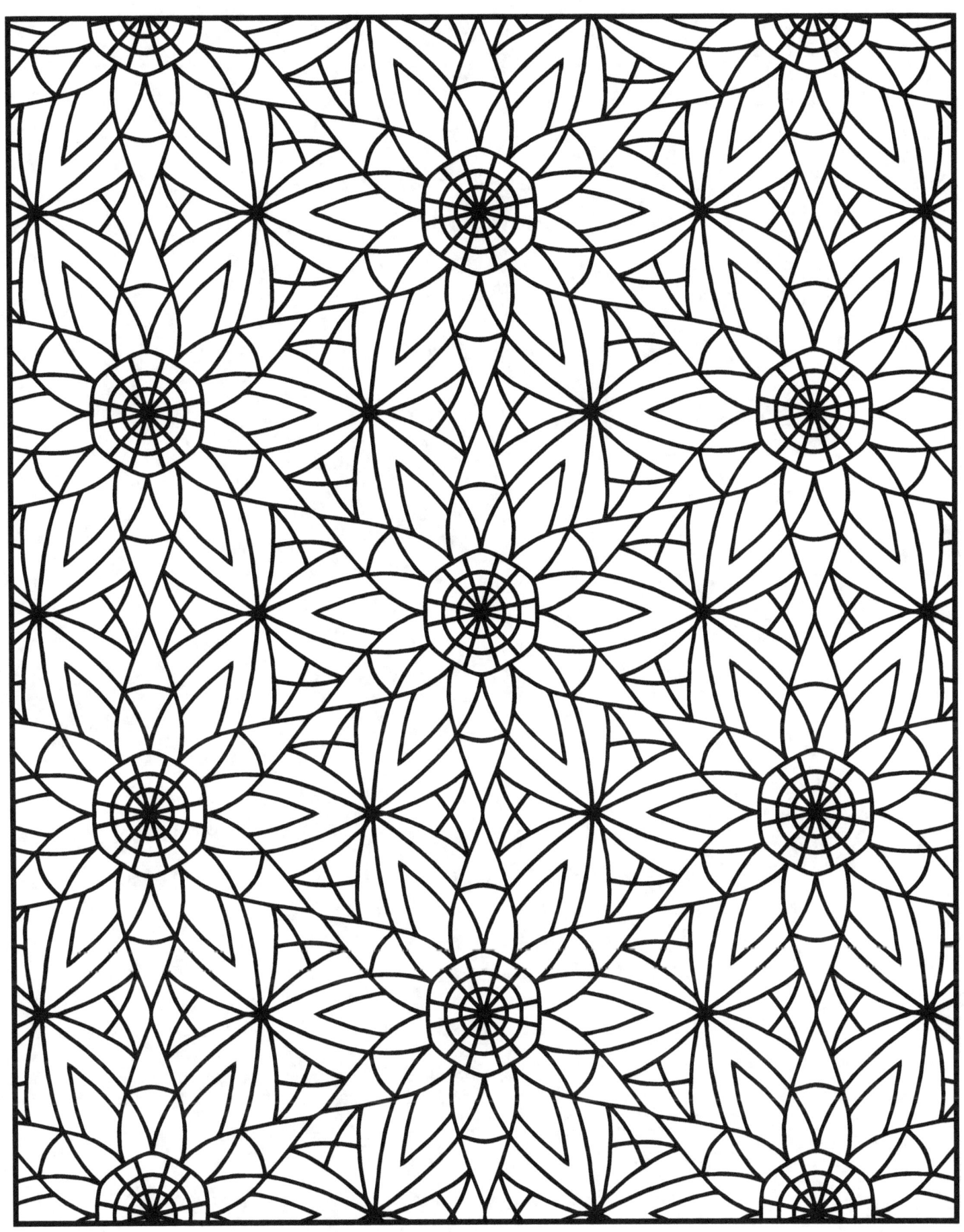

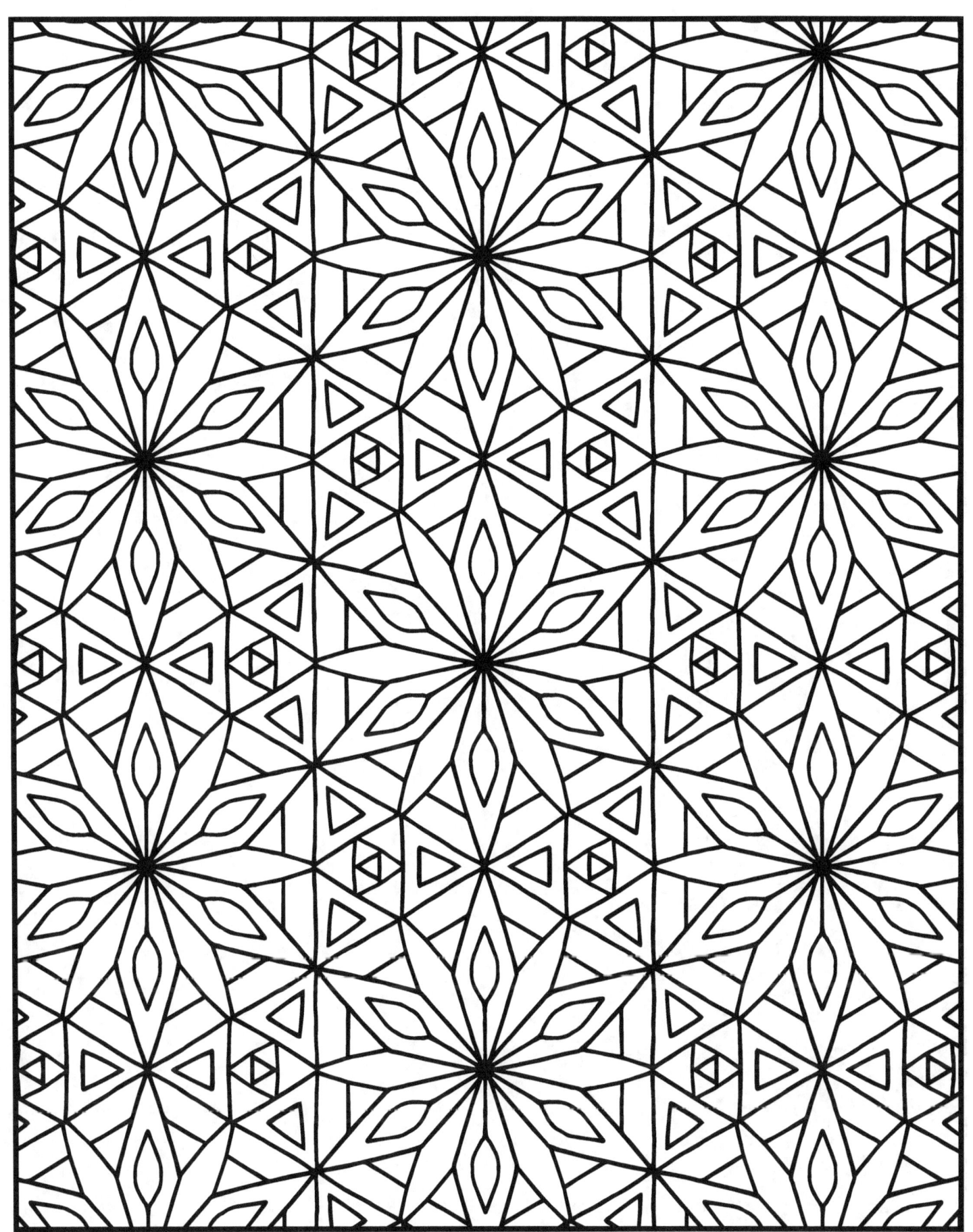

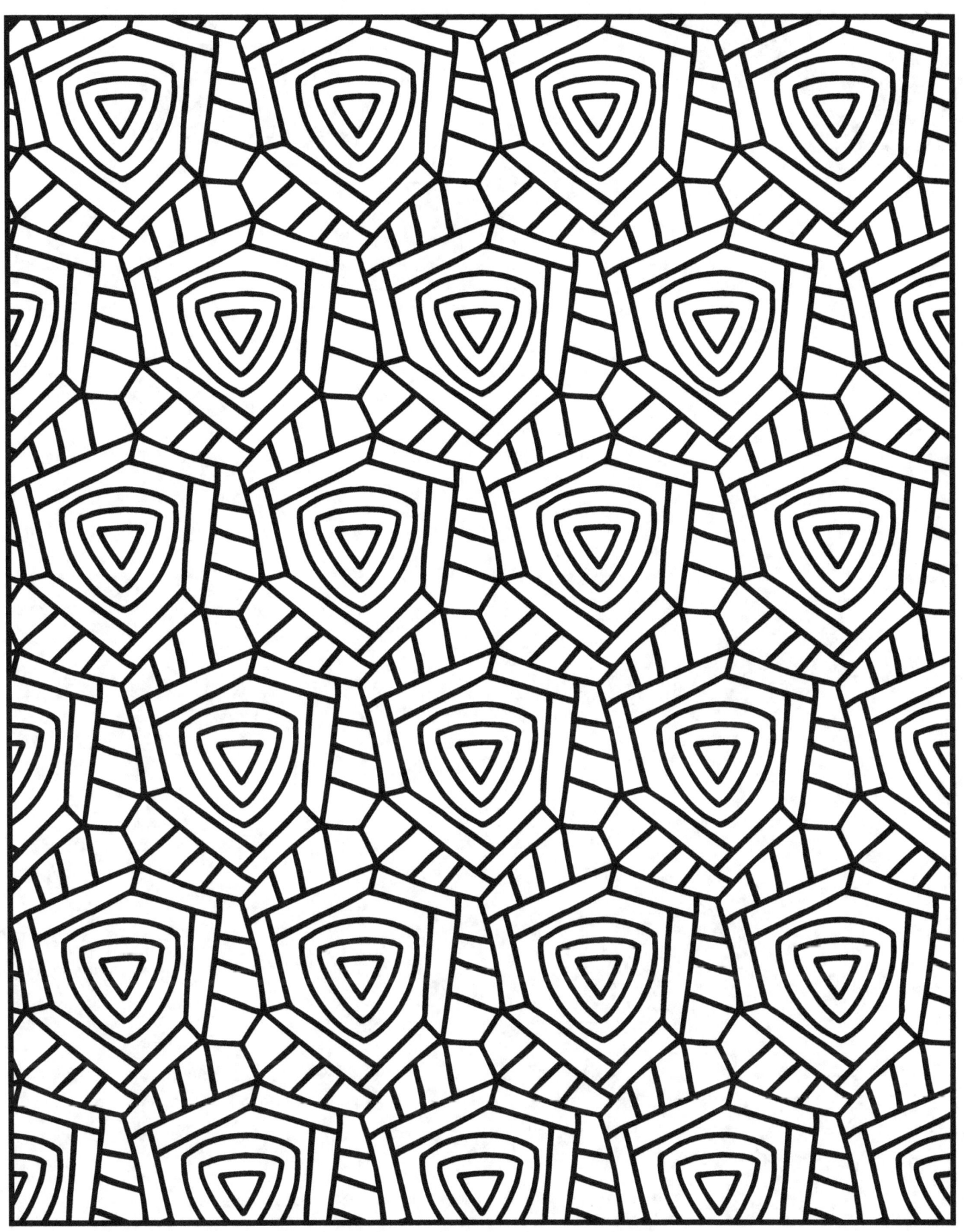

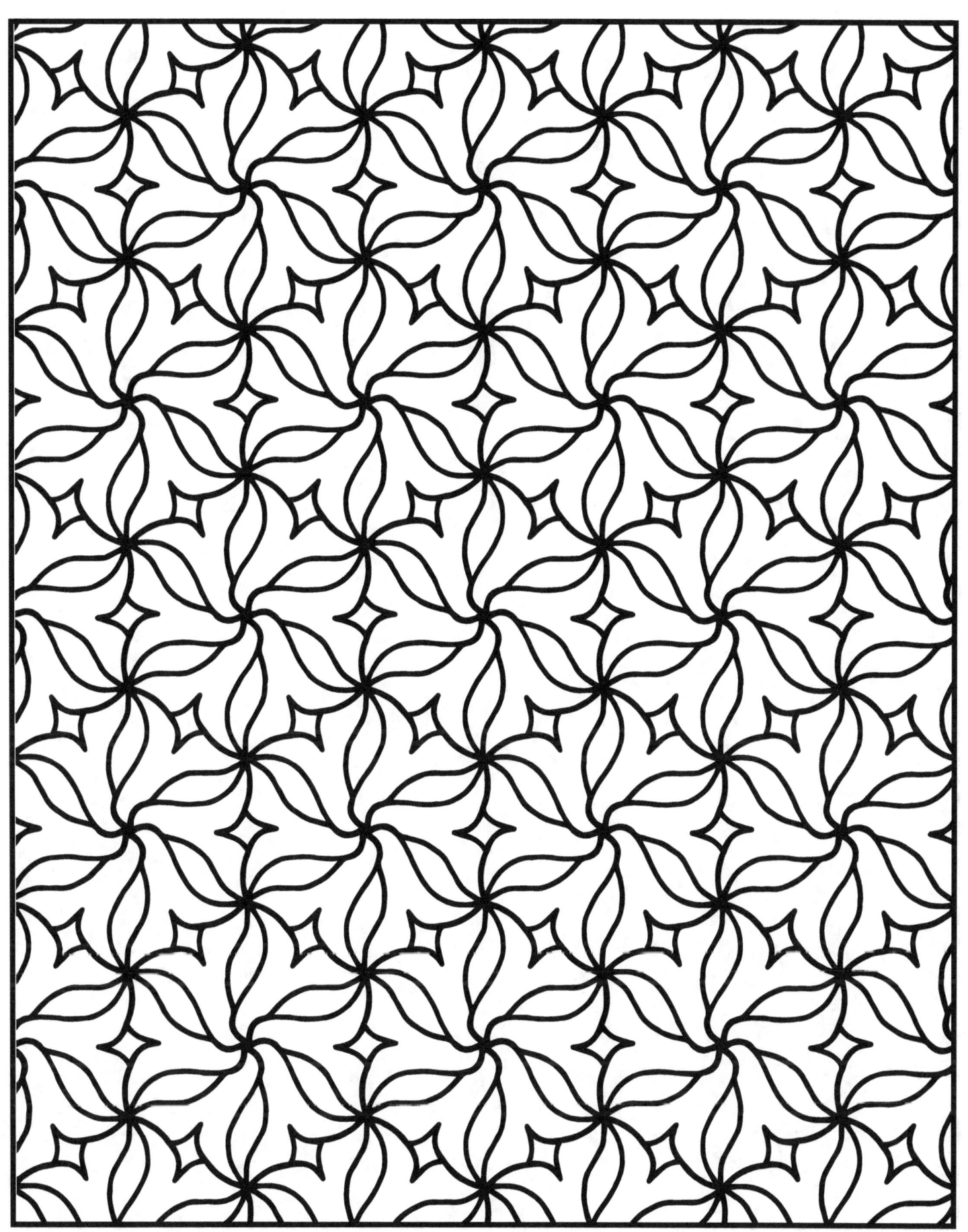

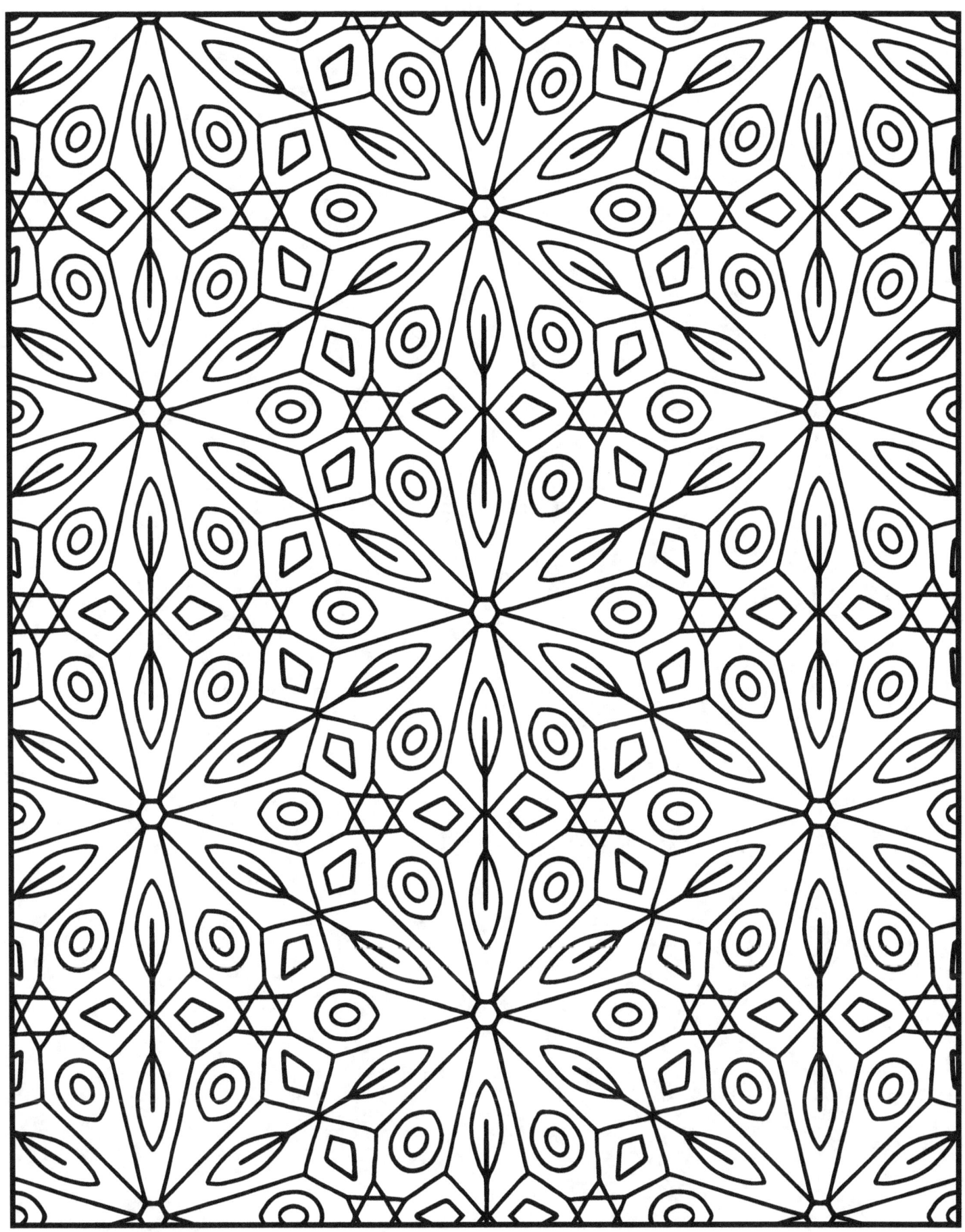

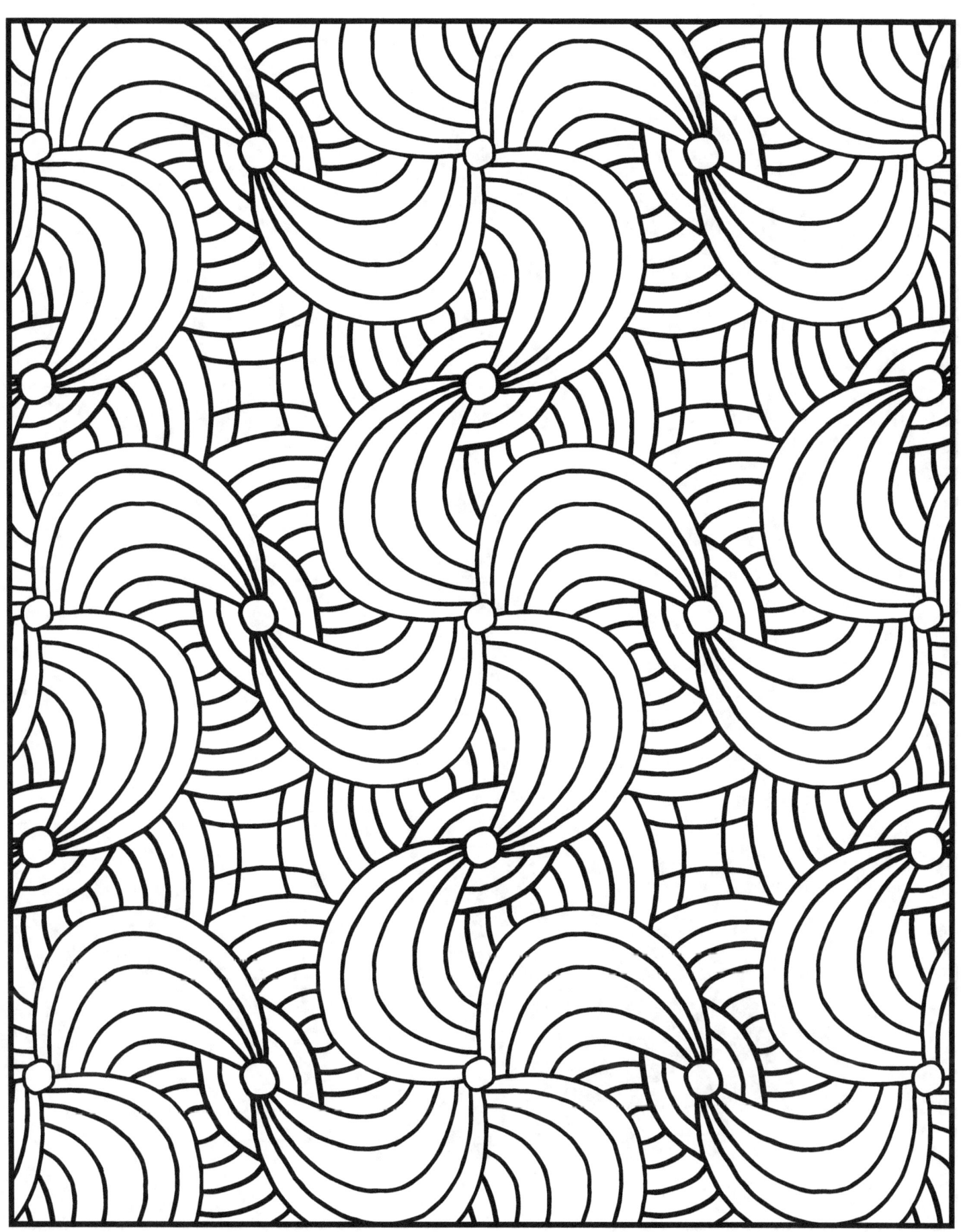

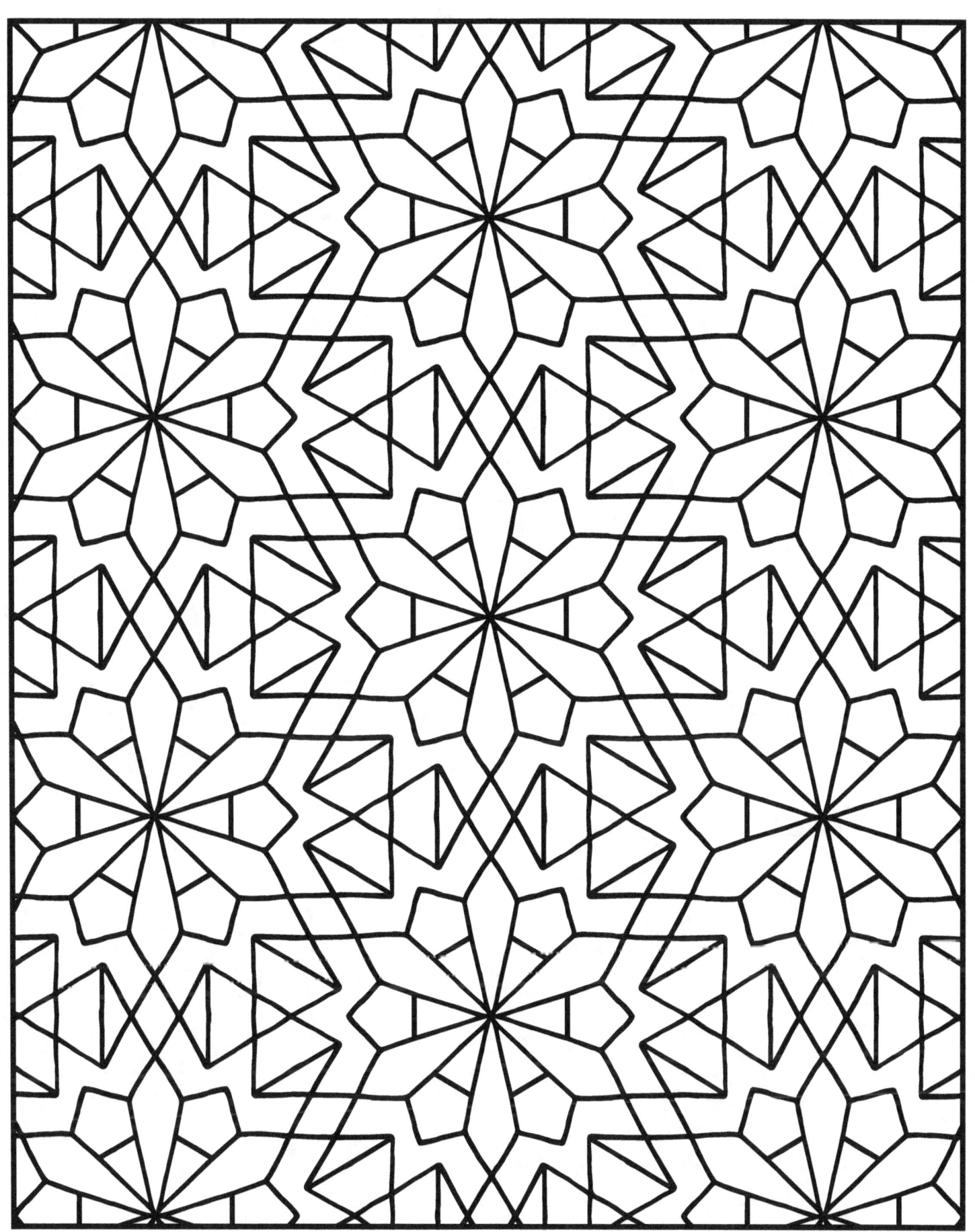

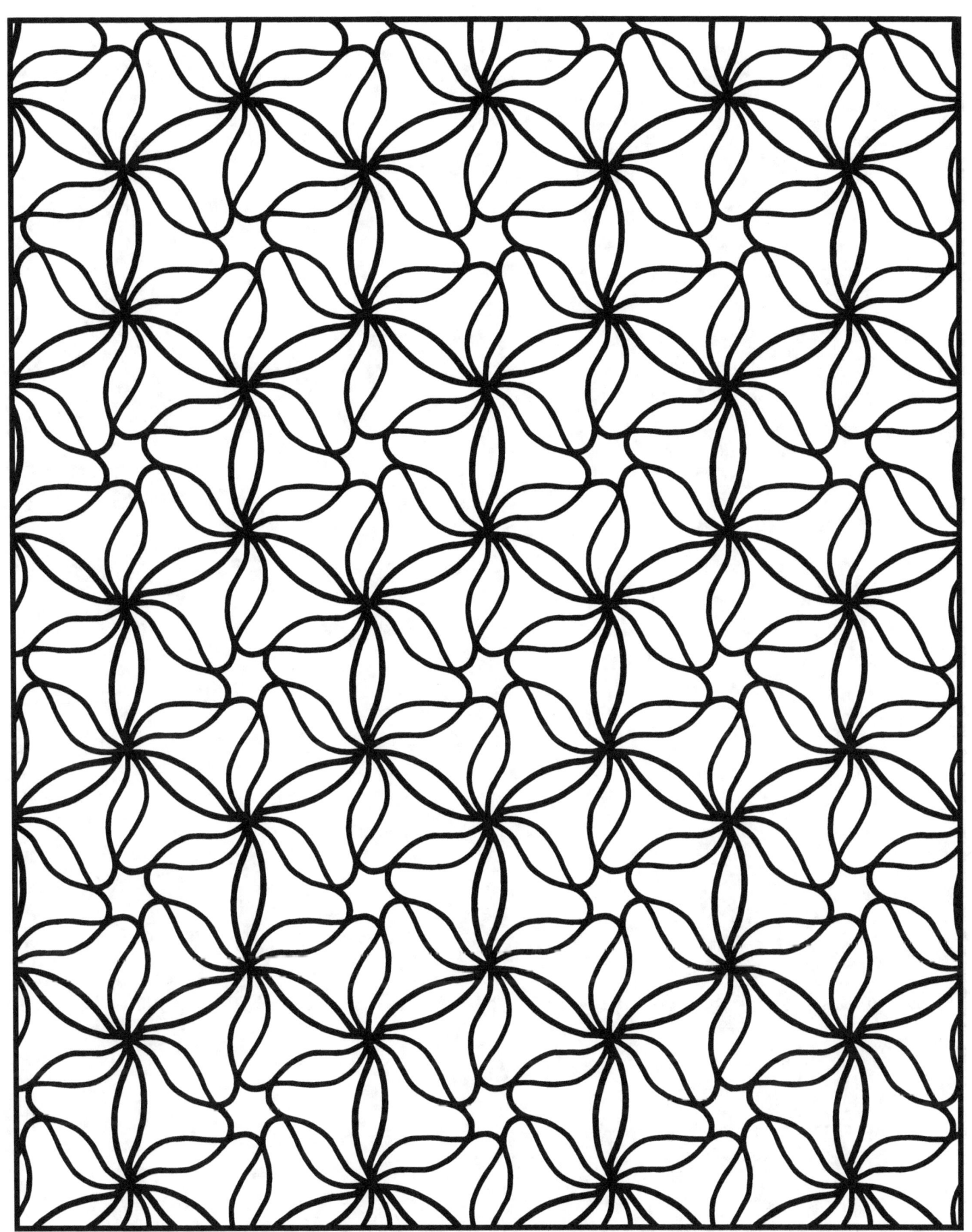

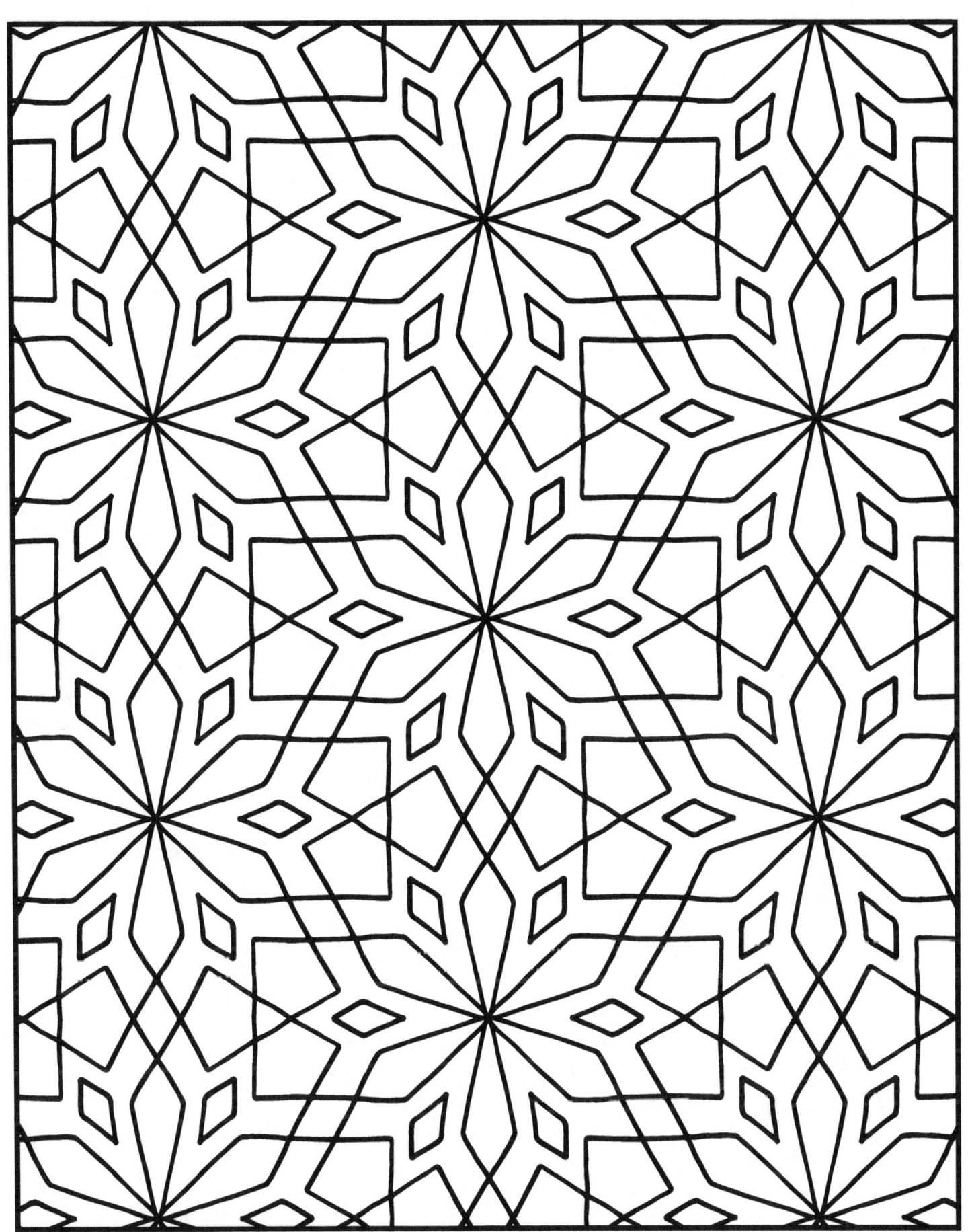

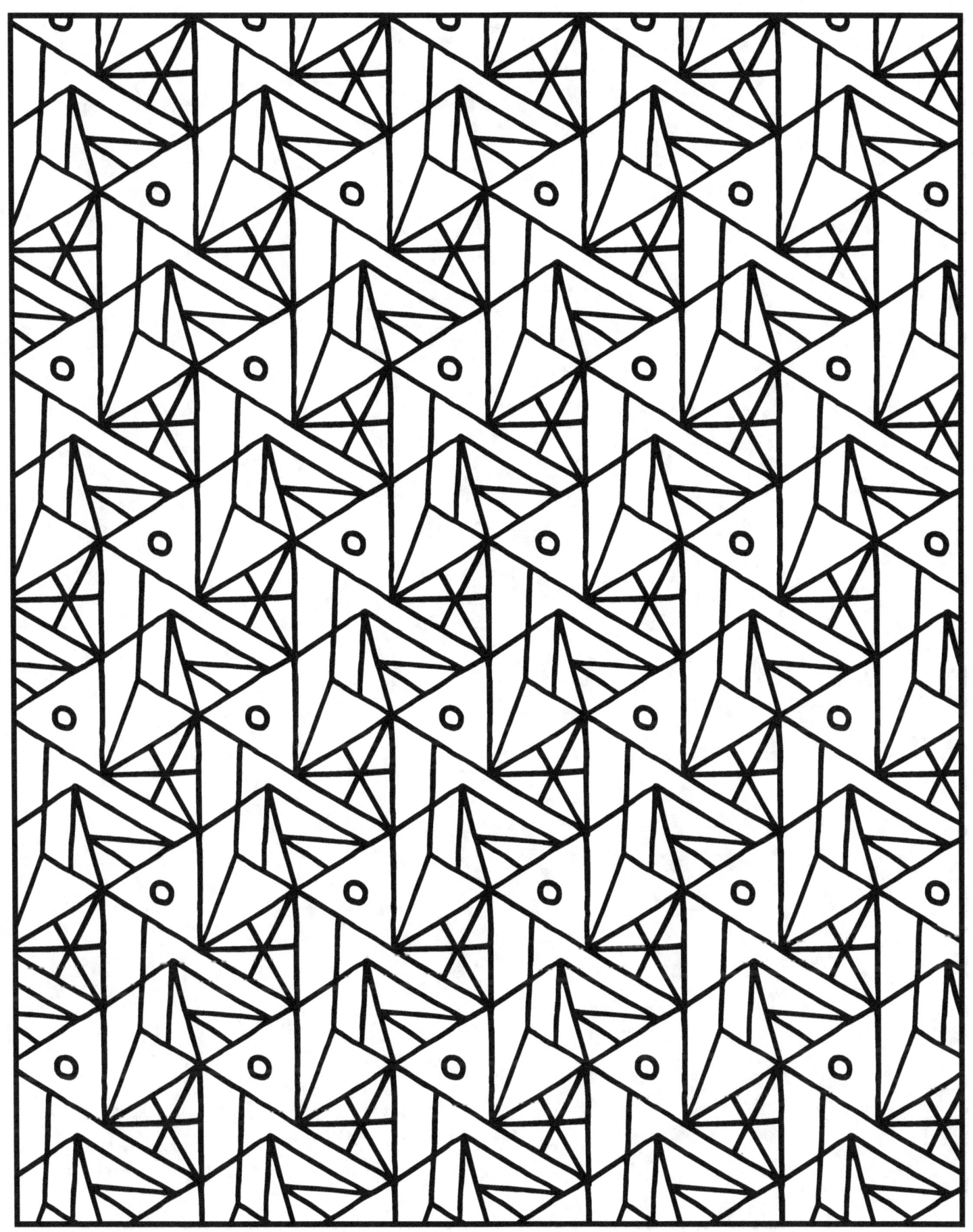

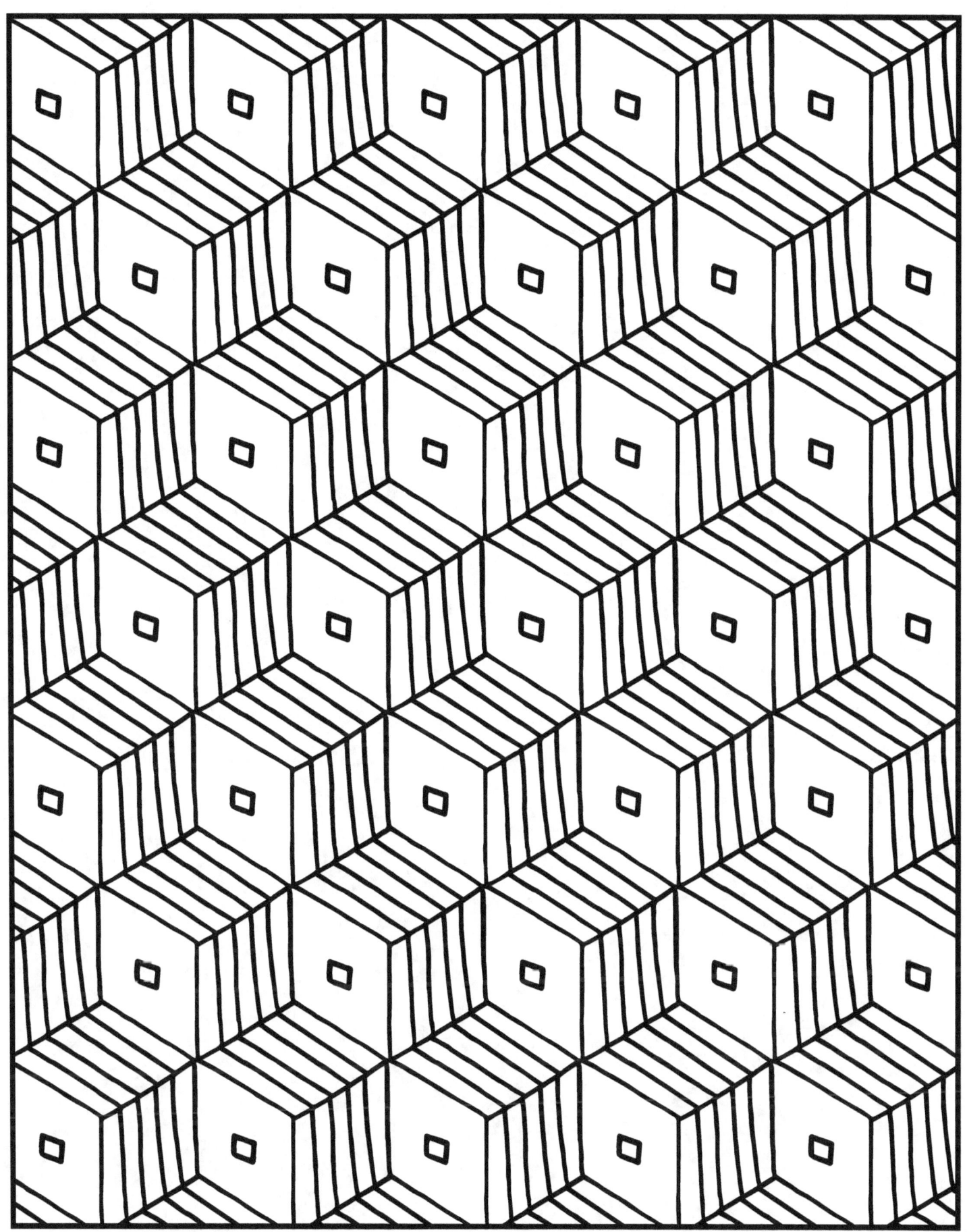

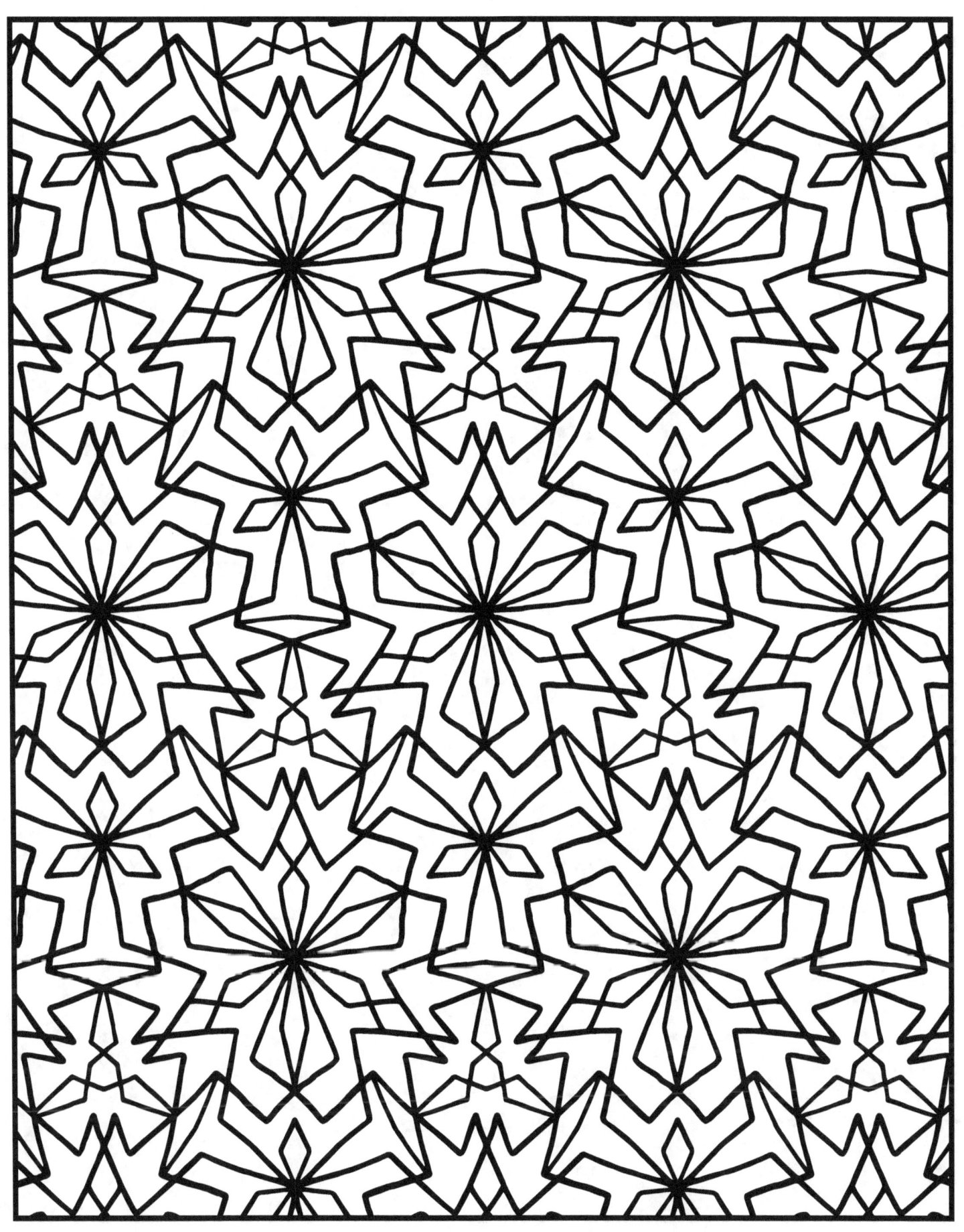

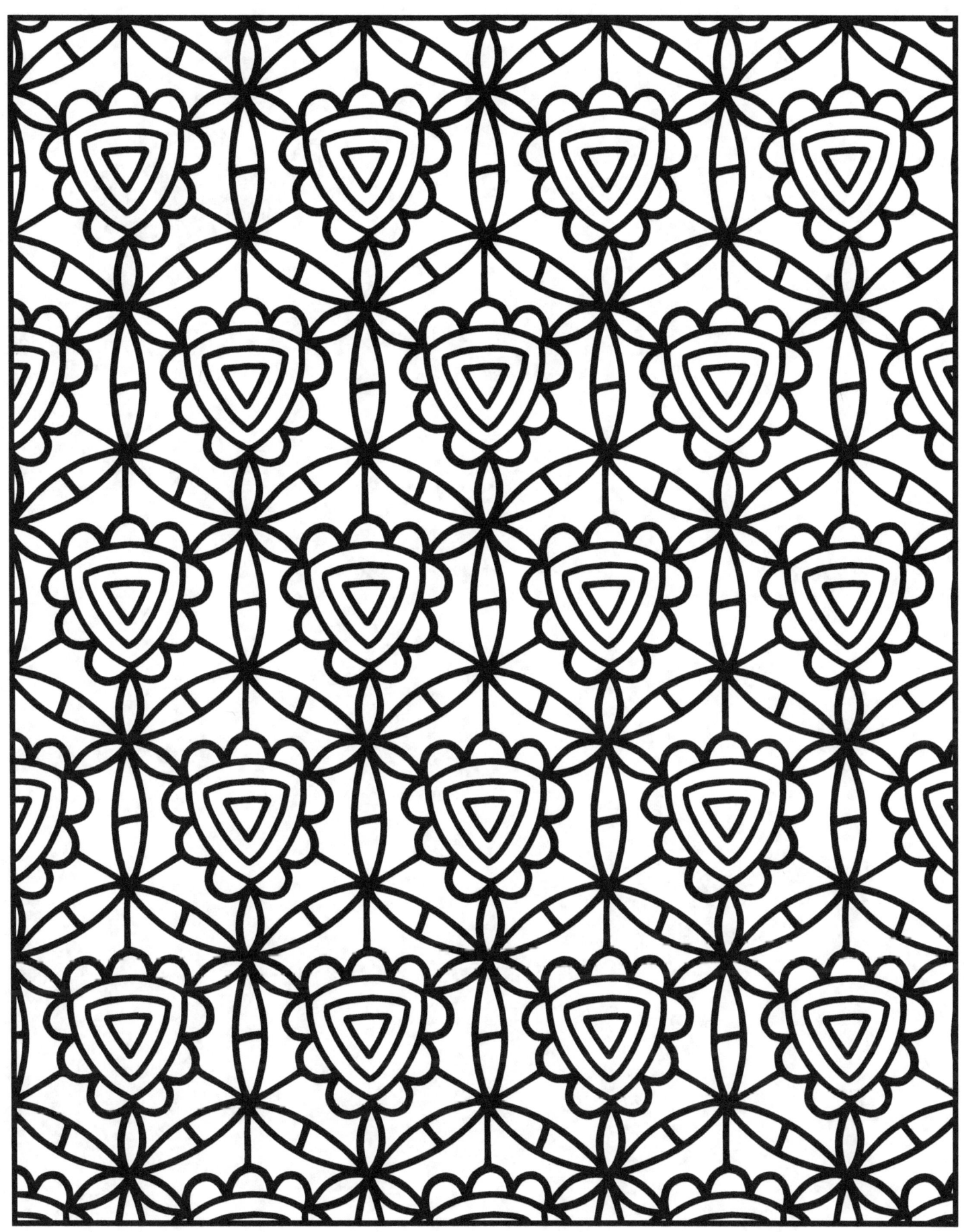

www.ingramcontent.com/pod-product-compliance
Lightning Source LLC
Chambersburg PA
CBHW080826170526
45158CB00009B/2535